She Believed She Could, So She Did

This Is The Personal

JOURNAL

Of

Copyright 2019 June Bug Journals
All Rights Reserved

Lightning Source UK Ltd.
Milton Keynes UK
UKHW050737081019
351160UK00005B/107/P